clothe ... ies

a

Yishan Li

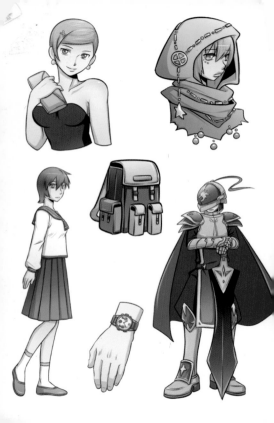

clothes & accessories

the pocket reference to drawing manga

Yishan Li

Search Press

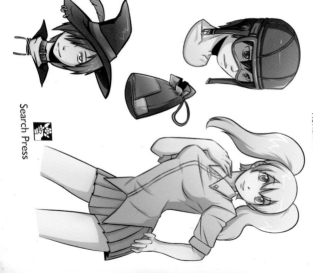

First published in Great Britain 2011 by
Search Press Limited
Wellwood, North Farm Road,
Tunbridge Wells, Kent TN2 3DR

Copyright © 2011 Axis Publishing Limited

Created and conceived by
Axis Publishing Limited
8c Accommodation Road
London NW11 8ED
www.axispublishing.co.uk

Creative Director: Siân Keogh
Editor: Anna Southgate
Designer: Simon de Lotz
Production: Bili Books

ISBN: 978-1-84448-544-4

contents

Introduction

Manga art has its origins in Japan. The term is actually the Japanese word for 'comic', as it was in Japanese comic strips that such characters were first seen. This unique style of drawing has one common theme: despite many of the characters having an other-worldly appearance, their features are almost always based on the human model.

manga style

The weird looks of manga characters rely on their human features being exaggerated somehow. Their huge eyes dominate the face and they often have very skinny waists or ultra-long legs. A deliberate ambiguity makes it difficult to determine a character's gender, and that is where this book comes in.

Armed with a vivid imagination and the projects in this book, you will discover how to draw an infinite range of clothes and accessories for your own manga creations.

so how does it work?

This book has three main sections: the basics; male and female clothing; and accessories.

This character bears the traits of Stone Age man. With a handful of leaves for clothing, a crude wooden club is his only protection.

Step by step, the projects in each section show you how to draw convincing manga characters – from the first rough sketch to finished artwork.

the basics

In this section, you will learn how to capture the look and feel of a wide range of different materials, from cotton to lycra and metal to wool, and how they crease and fold when worn. You will also discover how to draw the basic clothing that you are likely to return to again and again – the cotton t-shirt, denim jeans and metal armour.

male and female clothing

This section offers 15 step-by-step projects for drawing a diverse range of clothes for male and female characters. Many of them can be

adapted for a range of different people and situations, giving you endless scope for development. You will find traditional costumes here, as well as uniforms for specific professions (military, office worker, police officer). There are also examples of various fashions, such as punk, goth and hip-hop.

accessories

This last section offers 17 step projects for all manner of accessories from hats, bags and belts to gloves, scarves and jewellery.

Whether a car mechanic or a boxer, an air stewardess or a schoolgirl, choosing the right clothing brings a character to life.

equipment

In order to create your own manga art, it is a good idea to invest in a range of materials and equipment. The basics include paper for sketches and finished artworks, pencils and inking pens for drawing, and colour pencils, markers or paints for finishing off. There are also a handful of drawing aids that will help produce more professional results.

drawing

Every manga character must start with a pencil sketch
– this is essential. You need to build each figure
gradually, starting with a structural guide and adding
body features, then clothes, in layers. The best way to do
this effectively is by using a pencil.

pencils

You can use a traditional graphite pencil or a mechanical
one according to preference. The advantages of the latter
are that it comes in different widths and does not need
sharpening. Both sorts are available in a range of hard
leads (1H to 6H) or soft leads (1B to 6B); the higher the
number in each case, the harder or softer the pencil. An
HB pencil is halfway between the two ranges and will give
you accurate hand-drawn lines. For freer, looser sketches,
opt for something softer – say a 2B lead.

Some of the sketches in this book are drawn using a
blue lead. This is particularly useful if you intend to
produce your artworks digitally, as blue does not show up
when photocopied or scanned. If you opt for a traditional
graphite pencil, you will also need a pencil sharpener.

*An eraser or putty eraser is
an essential tool. Use it to
remove and correct
unwanted lines or to white-
out those areas that need
highlights. Choose a good-
quality eraser that will not
smudge your work.*

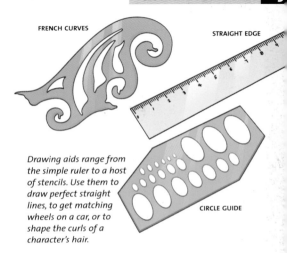

FRENCH CURVES

STRAIGHT EDGE

CIRCLE GUIDE

Drawing aids range from the simple ruler to a host of stencils. Use them to draw perfect straight lines, to get matching wheels on a car, or to shape the curls of a character's hair.

drawing aids and guides

The tips in this book show you how to draw convincing manga characters from scratch by hand. There may be times, however, when drawing by hand proves a little too difficult. Say your composition features a futuristic city scape; you might want to use a ruler to render the straight edges of the buildings more accurately. The same could be true if you wanted to draw more precise geometric shapes – a true circle for the sun, for example.

inking and colouring

Once you have drawn your manga character in pencil, you can start to add colour. This is where you can really let your imagination run free. There are numerous art materials available for inking and colouring, and it pays to find out which ones suit you best.

inking

A good manga character relies on having a crisp, clean, solid black outline, and the best way to achieve this is by using ink. You have two choices here. First is the more traditional technique, using pen and ink. This involves a nib with an ink cartridge, which you mount in a pen holder. The benefit of using this method is that you can vary the thickness of the strokes you draw, depending on how much pressure you apply as you work. You also tend to get a high-quality ink. The alternative to using pen and ink is the felt-tipped drawing pen, which comes in a range of widths. A thin-nibbed pen (0.5mm) is best, but it is also a good idea to have a medium-nibbed pen (0.8mm) for more solid blocks of ink. Whichever option you go for, make sure the ink is quick-drying and/or waterproof so that it does not run or smudge as you work.

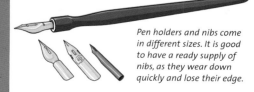

Pen holders and nibs come in different sizes. It is good to have a ready supply of nibs, as they wear down quickly and lose their edge.

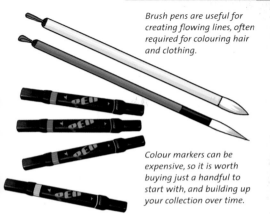

Brush pens are useful for creating flowing lines, often required for colouring hair and clothing.

Colour markers can be expensive, so it is worth buying just a handful to start with, and building up your collection over time.

colouring

There are various options available to you when it comes to colouring your work. The most popular method is to use marker pens. These are fast-drying and available in very many colours. You can use them to build up layers of colour, which really helps when it comes to creating shading in, say, hair or clothing. You can also use colour pencils and paints very effectively (gouache or watercolour). Colour pencils and watercolours are probably the most effective media for building up areas of tone – say for skin – and also for blending colours here and there. White gouache is very useful for creating highlights, and is best applied with a brush.

papers

It is difficult to imagine that you will have the perfect idea for a character every time you want to draw a manga scenario. These need to be worked at – not just in terms of appearance – but also in terms of personality. It is a good idea, therefore, to have a sketchbook to hand so that you can try out different ideas. Tracing paper is best for this, as its smooth surface allows you to sketch more freely. You can also erase unwanted lines several times over without tearing the paper. A recommended weight for tracing paper is 90gsm.

Having sketched out a few ideas you will want to start on a proper composition, where you move from pencil outline to inked drawing to finished coloured art. If you are tracing over a sketch you have already made, it is best to use paper that is only slightly opaque, say 60gsm. In order to stop your colours bleeding as you work, it is important that you buy 'marker' or 'layout' paper. Both of these are good at holding colour without it running over your inked lines and blurring the edges. 'Drawing' paper is your best option if you are using just coloured pencils with the inked outline, while watercolour paper is, of course, ideal for painting with watercolour – a heavyweight paper will hold wet paint and colour marker well. You also have a choice of textures here.

It is always best to allow space around the edge of your composition, to make sure that the illustration will fill the frame.

using a computer

The focus of this book is in learning how to draw and colour manga characters by hand. Gradually, by practising the steps over and again you will find that your sketches come easily and the more difficult features, such as hands, feet and eyes, begin to look more convincing. Once that happens, you will be confident enough to expand on the range of characters you draw. You might even begin to compose cartoon strips of your own or, at the very least, draw compositions in which several characters interact with each other – such as a battle scene.

Once you reach this stage, you might find it useful to start using a computer alongside your regular art materials. Used with a software program, like Adobe Photoshop, you can colour scanned-in sketches quickly and easily. You will also have a much wider range of colours to use, and can experiment at will.

Any home computer can be used for colouring your manga sketches in order to produce finished art.

You can input a drawing straight into a computer program by using a graphics tablet and pen. The tablet plugs into your computer, much like a keyboard or mouse.

Moving one step further, a computer can save you a lot of time and energy when it comes to producing comic strips. Most software programs enable you to build a picture in layers. This means that you could have a general background layer – say a mountainous landscape – that always stays the same, plus a number of subsequent layers on which you can build your story. For example, you could use one layer for activity that takes place in the sky and another layer for activity that takes place on the ground. This means that you can create numerous frames simply by making changes to one layer, while leaving the others as they are. There is still a lot of work involved, but working this way does save you from having to draw the entire frame from scratch each time.

Of course, following this path means that you must invest in a computer if you don't already have one. You will also need a scanner and the relevant software. All of this can be expensive and it is worth getting your hand-drawn sketches up to a fairly accomplished level before investing too much money.

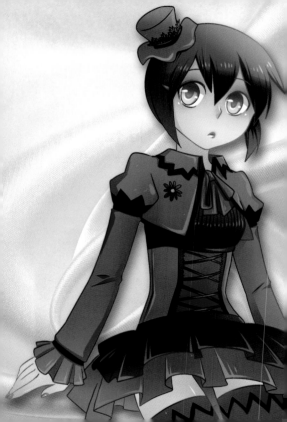

the basics

The best place to start with clothing and accessories is to get to grips with a few manga staples – the cotton t-shirt, denim jeans and armour plate. Get a feel for a wide range of different fabrics and how they look when folded or creased. You should also consider how clothing choices change according to age, gender and season.

age and gender

Although you can dress your characters in any clothes of your choice, it is worth noting some age and gender conventions.

Young boys tend to wear loose-fitting comfortable and practical clothes. Hoodies, cotton t-shirts, shorts and trainers are typical of this age group.

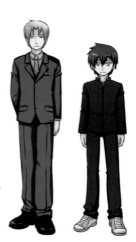

Teenage boys and adult men have a smarter look than young children. They might wear a well-cut suit, jeans and a shirt or a uniform of some kind.

There are more options for dressing young girls than there are for boys. As well as jeans and a t-shirt, you can choose from all manner of cute dresses, tops and skirts.

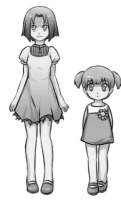

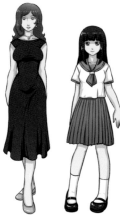

Teenage girls and adult women also offer more variety, ranging from power-tripping pants or skirt suits to practical day wear and glamorous evening wear.

materials

The next few pages consider the different types of fabric clothes are made from and how they look when worn.

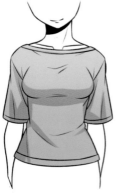

It is important to consider seasonal variations. In the hotter months, shirts and dresses tend to have short sleeves or no sleeves at all. Typical fabrics include light cottons, silks and lycra.

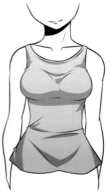

Summer fabrics often cling to the natural curves of the body. Use thin inking lines to help capture the shape. You, also need to consider the body curves when drawing in any shadows.

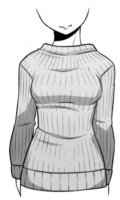

Clothing during the colder months is usually made from thicker materials, such as wool and fur. They tend to make the body look slightly fatter.

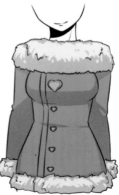

The natural curves of the body are less visible than with summer clothes. Winter clothes also tend to have fewer folds or drapes, because of the heavier-weight fabrics.

cotton t-shirt

The cotton t-shirt is the most basic item of clothing. It can be adapted for a range of poses for both men and women.

1 Draw a pencil outline of your figure. Using this as a guide, sketch in the clothes. Follow the shape of the body, allowing for those areas of the t-shirt that are looser than others – the sleeves, for example.

2 Work on the rest of your character, drawing in hair and facial features. Go over your outline in ink to give the t-shirt a more solid form.

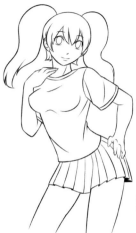

4 Erase any unwanted pencil lines and add colour to your work. Use flat colour to render the matt quality of the cotton fabric. Use the natural curves of the body to help place soft shadows.

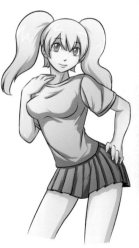

3 The cotton material of the t-shirt is soft and light. Keep your lines thin to reflect this. Use simple lines to give shape to the bust area and to emphasise the tapering at the waist.

polyester shirt

A polyester shirt has a more rigid structure than one made from cotton and is generally stiffer.

1 Draw a pencil outline of your figure. Using this as a guide, sketch in the shirt. Follow the shape of the body, but use short, straight lines to capture the close-fitting, stiff nature of the fabric.

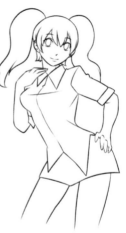

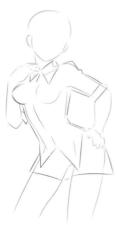

2 Work on the rest of your character, drawing in hair and facial features. Go over your outline in ink to give the shirt a more solid form.

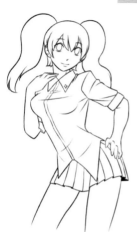

4 Erase any unwanted pencil lines and add colour to your work. Take care with any shadows: the stiffness of the fabric means there should be more contrast between areas of light and dark.

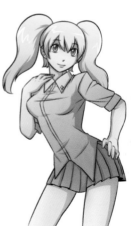

3 Start to add more detail. The polyester material has less stretch than cotton. Use simple lines to give shape to the shirt, emphasising those areas that are tighter than others.

silk dress

Silk is a very light, soft fabric. It has an almost fluid quality to it, shifting and swaying with the slightest movement.

1 Draw a pencil outline of your figure. Using this as a guide, sketch in the dress. Follow the shape of the body and use a few simple lines to capture the way in which the fabric hangs.

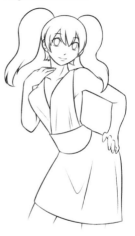

2 Work on the rest of your character, drawing in hair and facial features. Go over your outline in ink to give the dress a more solid form.

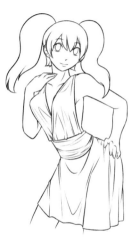

4 Erase any unwanted pencil lines and add colour to your work. Keep the shadows to those areas where the fabric drapes, and use a few highlights to emphasise the folds.

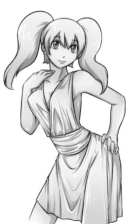

3 The silk material of this dress makes it softer and more fluid than clothes made from cotton. Use many thin lines to show how the fabric creases and folds.

wool sweater

The natural curves of the body are less apparent in wool clothing than in lighter fabrics.

1 Draw a pencil outline of your figure. Using this as a guide, sketch in the sweater. Allow for the thickness of the fabric as you follow the general shape of the body.

2 Work on the rest of your character, drawing in hair and facial features. Go over your outline in ink to give the sweater a more solid form.

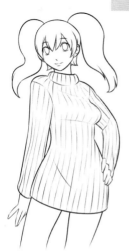

4 Erase any unwanted pencil lines and finish your artwork. Use flat colours and follow the natural curves of the body to place soft shadows on the vertical ribs and below the bust.

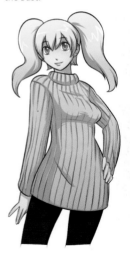

3 Although chunky, this sweater still hugs the character's figure. Draw lines to show how the vertical ribbing follows the body's curves. Use a couple of horizontal lines to emphasise the bust area.

fur-trim coat

This exercise combines the stiff heavy fabric of the coat with the soft fluffy nature of the fur trim.

1 Draw a pencil outline of your figure. Using this as a guide, sketch in the coat. Follow the shape of the body loosely, using long flowing lines to capture a basic outline only.

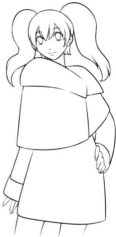

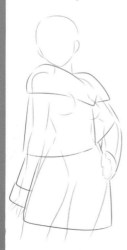

2 Work on the rest of your character, drawing in hair and facial features. Go over your outline in ink to give the coat a more solid form.

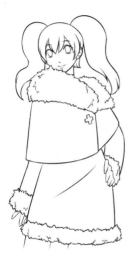

4 Erase unwanted pencil lines and colour your work. Use subtle shading to make the flat surfaces of the coat look realistic. Contrast dark shadows with the light colour of the fur to soften its look.

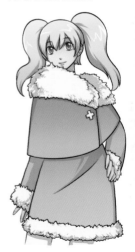

3 Use short, straight lines to capture the soft fur. Draw them going in different directions to give the trim a jagged appearance. This will soften once you start to add colour.

metal armour

The rigid nature of metal makes it ideal for creating all manner of wild designs.

1 Draw a pencil outline of your figure. Using this as a guide, sketch in the armour. Allow for the thickness and inflexibility of the metal as you follow just the general shape of the body.

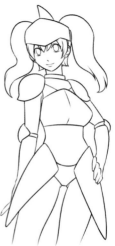

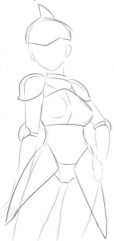

2 Work on the rest of your character, drawing in hair and facial features. Go over your outline in ink to give the armour a more solid form.

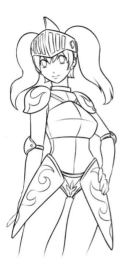

4 Erase any unwanted pencil lines and add colour to your work. Use strong colours for the painted metal. Add sharp white highlights to emphasise the metal as it catches the light.

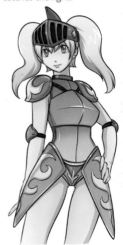

3 Start to add more detail. You need to rely on colour to capture the metal quality of the armour. Draw in some decorative details on the metal plate.

lycra swimsuit

Lycra is the closest-fitting fabric used for clothing. It follows the shape of the body, clinging to the curves.

1 Draw a pencil outline of your figure. Using this as a guide, sketch in the swimsuit. Follow the shape of the body closely, drawing your lines over the initial outline.

2 Work on the rest of your character, drawing in hair and facial features. Go over your outline in ink to give the swimsuit a more solid form.

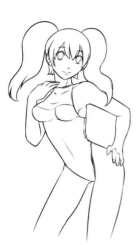

4 Erase any unwanted pencil lines and colour your work. Lycra often has a slight sheen to it, so add some white highlights to show this. Use the natural curves of the body to help place soft shadows.

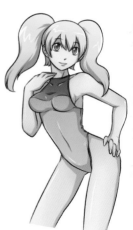

3 Lycra is soft, tight and clingy. Keep your lines thin to reflect this. Use simple lines to give shape to the bust area. Add the odd wrinkle where the fabric is less taut.

denim jeans

Denim is a popular choice for manga characters – male and female. Jeans can be long or short, straight or baggy.

1 Draw a pencil outline of your figure. Using this as a guide, sketch in the jeans. Follow the shape of the body (closely for tight jeans) and using strong fluid lines to capture the stiffness of the denim.

2 Improve on your basic outline by adding some details – pockets, a waistband and some turnups. Go over your outline in ink to give the jeans a more solid form.

4 Erase any unwanted pencil lines and add colour to your work. Use flat colour to render the matt quality of the denim fabric. Use the natural curves of the body to help place soft shadows.

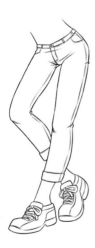

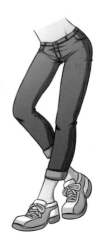

3 Draw faint lines to show where the seams are and draw in some stitching around the pockets. Add wrinkles where the denim is less taut – behind the knees, for example.

folds and creases

Clothes fold and crease as they fit around the body. The folds tend to be more prominent in lighter-weight fabrics.

1 Shirt collars and the tops of sweaters follow the natural curves of the neck and shoulder line.

2 Highlights emphasise the creases and folds in the fabric as it follows these natural curves.

1 Sleeves follow the curves of the arm – from the top of the shoulder down.

2 Highlights emphasise the pull of the fabric over the shoulder.

1 Creases in tops form centrally down the back and out towards the sides.

2 Use highlights to emphasise loose-fitting fabric around the waist.

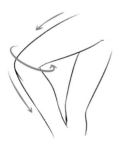

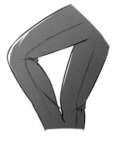

1 Pants tend to stretch down the front of the legs and at the knee.

2 Creases occur mostly at the back, especially when the leg is bent.

folds and creases continued

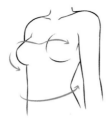

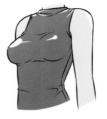

1 Tops stretch over the bust area but tend to be looser around the waist.

2 Creases form above and below the bust and around the waistline.

1 Skirts and dresses follow the natural curves of the body, from the waist down.

2 Highlights emphasise the folds in the fabric as it follows these curves.

1 Tops follow the line of the back vertically, from the shoulders down.

2 Highlights show the folds of the fabric as it follows the line of the back.

1 Pants hang vertically from the knee, and are loose around the foot area.

2 Highlights emphasise the folds of the fabric as it follows natural curves.

GALLERY

BELOW Complex, multilayered or gathered clothing will have a large number of folds.

ABOVE Creases radiate from the centre of a bent elbow or knee.

BELOW Pleated fabrics have creases and folds at regular intervals.

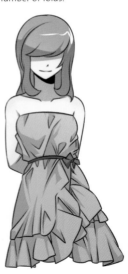

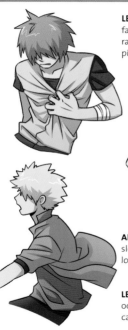

LEFT Grasped areas of fabric have loose folds radiating from a tight, pinched centre.

ABOVE Rolled or pushed-up sleeves form bands of looser fabric.

LEFT Soft, flowing folds occur when a fabric is caught by movement.

male and female clothing

From traditional Japanese and Chinese dress to medieval and ancient Greek costume, the range of clothing for your characters is infinite. In addition to customary outfits you will find models for everyday trends, such as punk and hip-hop, as well as ideas for various uniforms – the military, firefighters, the police – and fantasy figures.

male kimono

The kimono is a traditional form of Japanese clothing, with variations for both men and women.

1 Begin by drawing a pencil outline. Give the man a formal stance in keeping with the style of the clothing.

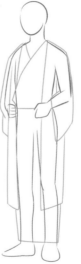

2 Use your outline as a guide for drawing the kimono. Use simple lines in order to achieve the basic shape of the garment.

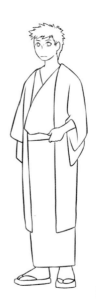

4 Trace the outline of the kimono and go over your whole artwork using ink. Give the man shoes.

3 Now trace the outline of your male figure, giving more shape to his natural curves. Give the character some hair and draw in the facial features.

▶▶

male kimono continued

5 Start to add more detail. Draw in lines to show how the layers build up beneath the outer garment. Give more shape to the shoes.

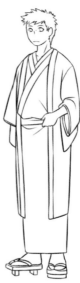

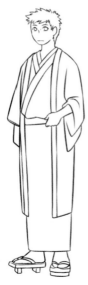

6 Consider where the lightweight fabric might be folded or creased, such as around the belt area, at the shoulders and in the crook of the elbow.

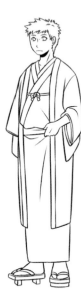

8 Colour your work. Pay particular attention to areas of light and shade, and use highlights to emphasise the folds.

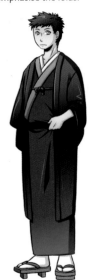

7 Add any final ink details, such as the shadow under the man's chin and the tie across his chest.

female kimono

Kimonos are often made from exquisite fabrics with all manner of elaborate patterns.

1 Begin by drawing a pencil outline. Give the woman a demure stance in keeping with the style of her clothing.

2 Use your outline as a guide for drawing the kimono. Use simple lines in order to achieve the basic shape of the garment.

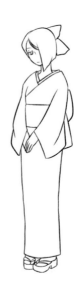

4 Trace the outline of the kimono and go over your whole artwork using ink. Draw in some shoes.

3 Now trace the outline of your female figure, giving more shape to her natural curves. Give the character some hair and draw in the facial features.

female kimono continued

5 Start to add more detail. Draw in lines to show how the layers build up beneath the outer garment. Give more shape to the sash at the waist.

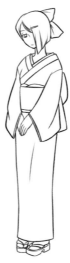

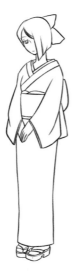

6 Consider where the lightweight fabric might be folded or creased, such down the front of the skirt area. Work on the hair decoration.

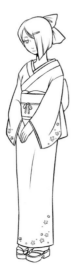

8 Colour your work. Pay particular attention to areas of light and shade, and use highlights to emphasise the folds.

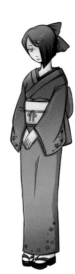

7 Add any final ink details, such as the shadow under the woman's chin and the pretty floral elements in the fabric.

kung-fu suit

A kung-fu suit must be practical in its design. It should be comfortable and allow for ease of movement.

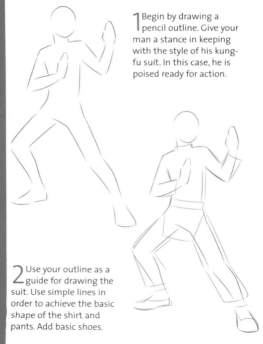

1 Begin by drawing a pencil outline. Give your man a stance in keeping with the style of his kung-fu suit. In this case, he is poised ready for action.

2 Use your outline as a guide for drawing the suit. Use simple lines in order to achieve the basic *shape* of the shirt and pants. Add basic shoes.

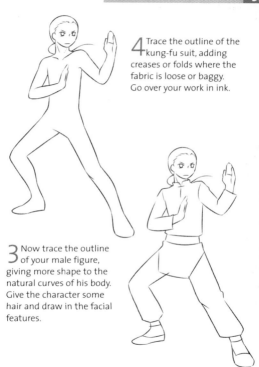

4 Trace the outline of the kung-fu suit, adding creases or folds where the fabric is loose or baggy. Go over your work in ink.

3 Now trace the outline of your male figure, giving more shape to the natural curves of his body. Give the character some hair and draw in the facial features.

▶▶

kung-fu suit continued

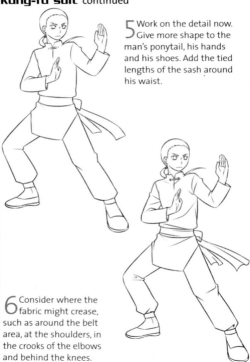

5 Work on the detail now. Give more shape to the man's ponytail, his hands and his shoes. Add the tied lengths of the sash around his waist.

6 Consider where the fabric might crease, such as around the belt area, at the shoulders, in the crooks of the elbows and behind the knees.

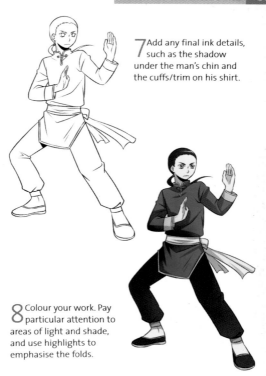

7 Add any final ink details, such as the shadow under the man's chin and the cuffs/trim on his shirt.

8 Colour your work. Pay particular attention to areas of light and shade, and use highlights to emphasise the folds.

traditional chinese dress

The traditional Chinese dress is typically made from silk. This version is full length, figure-hugging and has a high collar.

1 Begin by drawing a pencil outline. Give your character an elegant stance, in keeping with the style of her dress.

2 Use your outline as a guide for drawing the dress. Use simple lines in order to achieve the basic shape of the garment.

4 Trace the outline of the dress and go over your whole artwork using ink. Consider adding some accessories, such as the fan in this example.

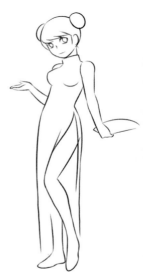

3 Now trace the outline of your female figure, giving more shape to her natural curves. Give the character some hair and draw in the facial features.

▶▶

traditional chinese dress continued

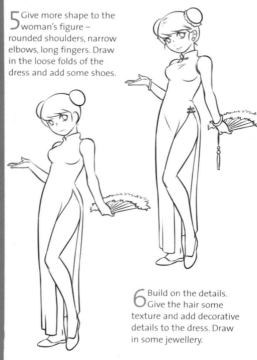

5 Give more shape to the woman's figure – rounded shoulders, narrow elbows, long fingers. Draw in the loose folds of the dress and add some shoes.

6 Build on the details. Give the hair some texture and add decorative details to the dress. Draw in some jewellery.

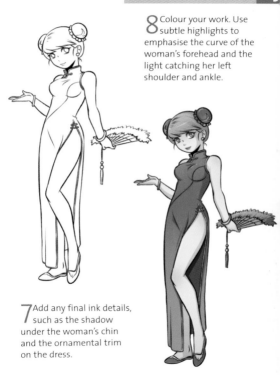

8 Colour your work. Use subtle highlights to emphasise the curve of the woman's forehead and the light catching her left shoulder and ankle.

7 Add any final ink details, such as the shadow under the woman's chin and the ornamental trim on the dress.

female court dress

This is a more European-style dress, associated with early 19th-century royalty or the aristocracy.

2 Use your outline as a guide for drawing the dress. Use simple lines to achieve the basic shape.

1 Begin by drawing a pencil outline. Give your character an elegant stance, in keeping with the style of her dress.

4 Trace the outline of the dress, giving more shape to the sleeves and hemline. Go over your artwork using ink.

3 Now trace the outline of your female figure, giving more shape to her natural curves. Give the character some hair and draw in the facial features.

▶▶

female court dress continued

5 Start to add detail. Define the cuffs and add lines to show the layering of the dress and how the skirt fabric drapes.

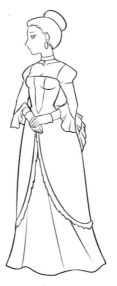

6 Build on the details. Draw in some jewellery. Add decorative details to the dress. Give more shape to the bustle.

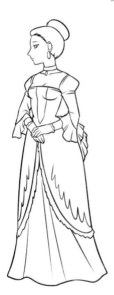

8 Colour your work. Use the natural curves of the body to help define soft shadows. Add subtle highlights to show where the dress catches the light.

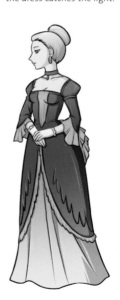

7 Add any final ink details, such as the ornamental trim on the dress and the frilled edge on the gloves.

male court clothes

This is a Western-style outfit, associated with royal courts and the nobility of early 19th-century Europe.

1 Begin by drawing a pencil outline. Give the man a formal stance in keeping with the style of the clothing.

2 Use your outline as a guide for drawing the clothing. Use simple lines to achieve the basic shape of the garments.

4 Trace the outline of the clothing, give it more shape, and go over your whole artwork using ink. Draw in some shoes.

3 Now trace the outline of your male figure, giving more shape to the natural curves. Give the character some hair and draw in the facial features.

male court clothes continued

5 Start to add more detail. Draw in the outline of a cravat at the neck. Draw in some cuffs and buckles on the shoes.

6 Add the decorative elements, such as the buttons on the shirt front. Make a start on the trim of the jacket. Give more definition to the shoes.

8 Colour your work, using sombre tones to reflect the formality of the clothing. Use highlights to show where the luxuriant materials catch the light.

7 Add any final ink details, such as the shadow under the man's chin and creases in his clothing. Finish the trim on the jacket and the shoes.

female ancient greek

This is a full-length, tunic-style dress in keeping with the traditional style of ancient Greece.

1 Begin by drawing a pencil outline. Give your character a stance that is in keeping with the style of her dress.

2 Use your outline as a guide for drawing the dress. Use simple lines in order to achieve the basic shape of the garment.

4 Trace the outline of the dress, giving it more shape, and go over your whole artwork using ink. Add some details, such as the buckle at the shoulder. Draw in the woman's toes.

3 Now trace the outline of your female figure, giving more shape to her natural curves. Give the character some hair and a foliage headband. Draw in the facial features.

▶▶

female ancient greek continued

5 Add some lines to capture the loose nature of the dress. The fabric is draped and flows freely. Draw in the shoe of the visible foot.

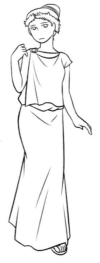

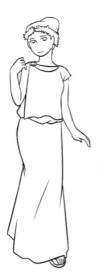

6 Build on the details. Give the hair some texture and draw in the decorative headband. Continue to build on the folds of the draped fabric.

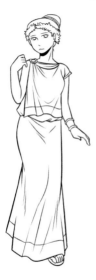

8 Colour your work. Use the natural curves of the woman's body to add some soft shadows. Darken the shadows in the folds of the cloth.

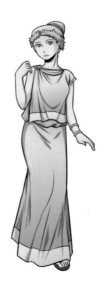

7 Add any final ink details, such as the shadow under the woman's chin and the panels of yellow fabric. Draw in some jewellery.

male ancient greek

Following the traditional style of ancient Greece, this man's tunic is shorter than that of the woman.

1 Begin by drawing a pencil outline. Position the arms in such a way as for holding a lyre.

2 Use your outline as a guide for drawing the tunic. Use simple lines in order to achieve the basic shape of the garment.

4 Trace the outline of the tunic, giving it more shape, and drape a robe over the man's left arm. Go over your artwork using ink. Draw in typical ancient Greek sandals.

3 Now trace the outline of your male figure, giving more shape to his natural curves. Give the character some hair and draw in the facial features.

▶▶

male ancient greek continued

5 Build on the detail. Draw in the outline of the lyre. Add folds in the loosely draped clothing. Embellish the sandals.

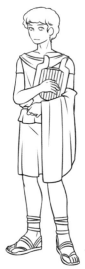

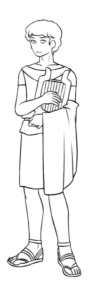

6 Keep adding to the folds of the draped cloth. Continue to embellish the sandals.

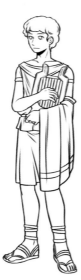

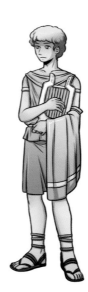

8 Colour your work, taking care with areas of light and shade. Use bright highlights to emphasise the luxuriance of the materials.

7 Add any final ink details, such as the shadow under the man's chin and the panels of yellow fabric.

GALLERY

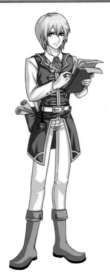

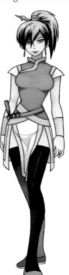

BELOW A fantasy female bodyguard, dressed in clothing for swift action.

ABOVE A medieval-style messenger in belted tunic, tights and high boots.

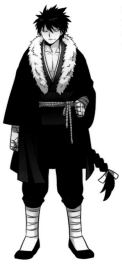

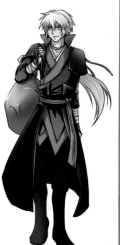

BELOW A fairy-tale-type traveller, his ornate clothing a symbol of his wealth and position.

ABOVE A medieval-style huntsman, wearing many layers for protection.

japanese schoolgirl

The traditional Japanese school uniform for girls is based on a sailor-suit design. There are many variations.

1 Begin by drawing a pencil outline. Give your schoolgirl a pose that is in keeping with her character.

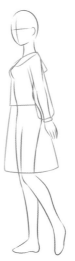

2 Use your outline as a guide for drawing the dress. Use simple lines to achieve the basic shape.

4 Trace the outline of the dress, giving more shape to the neckline. Draw in the pleats of the skirt and add some shoes. Go over your work in ink.

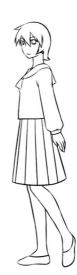

3 Now trace the outline of your female figure, giving more shape to her natural curves. Give the character some hair and draw in the facial features.

▶▶

japanese schoolgirl continued

5 Start to add detail. Draw in a crease to emphasise the loose, flowing nature of the sleeves. Add a sock line.

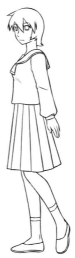

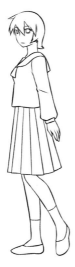

6 Build on the details. Give the shirt a decorative trim. Embellish the shoes and socks.

8 Colour your work. Add very soft shadows in the folds of the shirt, and stronger ones in the pleats of the skirt. Add subtle highlights to show where the girl's hair and shoes catch the light.

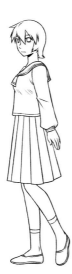

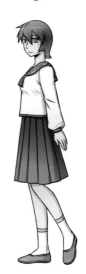

7 Add any final ink details, such as the short lines that give more definition to the bust area, an extra crease in the sleeve and the stripe in the blue trim on the shirt.

japanese schoolboy

The traditional Japanese school uniform for boys is based on a Prussian military uniform, usually in black or dark blue.

1 Begin by drawing a pencil outline. Here he has one hand in his pocket and the other slinging a satchel over his shoulder.

2 Use your outline as a guide for drawing the clothing. The uniform is a well-fitted suit, so keep your lines close to the body.

4 Trace the outline of the uniform, draw in the front seam of the jacket, and go over your artwork using ink. Draw outlines of the boy's shoes.

3 Now trace the outline of your male figure, giving more shape to his natural curves. Give the character some hair and draw in the facial features.

▶▶

japanese schoolboy continued

5 Start to add detail. Give more definition to the high collar and add wrinkles were the suit fabric is creased. Draw in the boy's satchel.

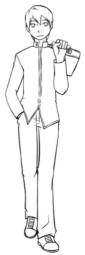

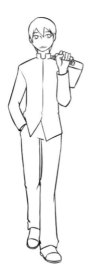

6 Add the decorative elements, such as seam detail on the jacket front. Put some creases in the pants. Draw in the laces of the shoes.

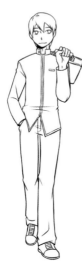

8 Colour your work, using sombre tones to reflect the nature of the clothing. Use highlights to show where the leather of the satchel catches the light.

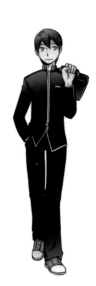

7 Add any final ink details, such as the shadow under the boy's chin, the top pocket of the jacket and the creases at his waist and elbow.

girl's summer outfit

This is a simple outfit, suitable for a young girl or teenager. The fabric should be soft and light.

1 Begin by drawing a pencil outline. Exaggerate the girl's form to give her a very narrow waist and long skinny legs.

2 Use your outline as a guide for drawing the outfit. Use simple lines to achieve the basic shape.

4 Trace the outline of the dress, giving more shape to the bust area and hemline. Add some shoes. Go over your work in ink.

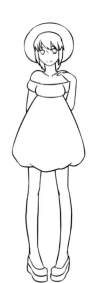

3 Now trace the outline of your female figure, giving more shape to her natural curves. Give the character some hair and draw in the facial features.

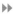

girl's summer outfit continued

5 Start to add detail. Draw in the ribbon at the back of the hat. Add a crinkled edged to the top of the dress. Begin to embellish the shoes.

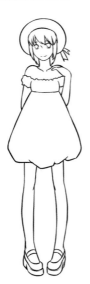

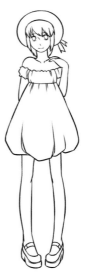

6 Build on the gathered seams around the bust area. Make more of the puff-ball skirt, drawing in a number of folds. Finish off the shoes.

8 Colour your work. Add very soft shadows in the folds of the skirt, and stronger ones in the pleats around the bust. Add subtle highlights where the fabric catches the light.

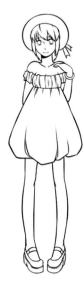

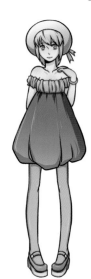

7 Add any final ink details, such as the shading under the girl's chin. Draw more gathered lines to the bust area.

boy's summer outfit

This outfit can be used for young boys and teenagers alike. You can adapt the length of the shorts to suit.

1 Begin by drawing a pencil outline. This character is holding a mobile phone and clutching his hoodie.

2 Use your outline as a guide for drawing the outfit. Use simple lines to achieve the basic shape.

4 Trace the outline of the outfit and go over your whole artwork using ink. Erase any unwanted pencil lines before moving on.

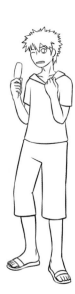

3 Now trace the outline of your male figure, giving more shape to his natural curves. Give the character some hair and draw in the facial features.

▶▶

boy's summer outfit continued

5 Start to add detail. Draw a front seam on the hoodie. Add a zip and pockets to the shorts. Give more shape to the sandals.

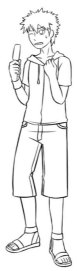

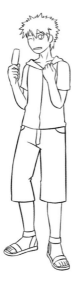

6 Draw the pull cord on the hoodie. Embellish the shorts, giving them seams and extra stitching around the pockets. Draw a sweatband on the boy's right wrist.

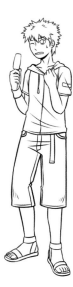

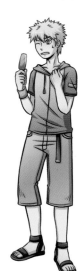

8 Colour your work. Add soft shadows, keeping them darker in the folds of the cloth. Add sharp highlights where the belt and shoes catch the light.

7 Add any final ink details, such as the shading under the boy's chin. Draw folds and creases where the clothes are loose on the body. Add a belt.

female office worker

Clothing for an office environment tends to be more formal than everyday or weekend wear.

1 Begin by drawing a pencil outline of your figure. Give the character a stance that exudes authority or efficiency.

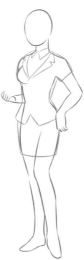

2 Use your outline as a guide for drawing the outfit – in this case a fitted suit. Use simple lines to achieve the basic shape.

4 Trace the outline of the suit, giving more shape to the jacket where it fits around the waist. Draw in the skirt and add some shoes and a folder. Go over your artwork in ink.

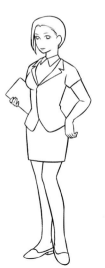

3 Now trace the outline of your female figure, giving more shape to her natural curves. Give the character some hair and draw in the facial features.

▶▶

female office worker continued

5 Start to add detail. Draw in a cravat at the neckline and mark a small 'V' in the front panel of the skirt.

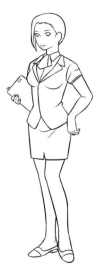

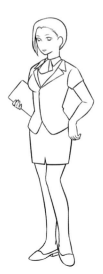

6 Think about the fabric the suit is made of. Draw in some lines to define the bust area and to show creases in the fabric here and there.

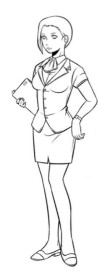

8 Colour your work. Use the natural curves of the body to add soft shadows. Add bright highlights to capture the sheen of the girl's tights where they catch the light.

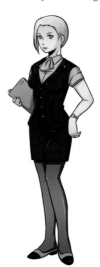

7 Add any final ink details, such as the shading under the worker's chin and the buttons on her suit. Draw a watch on the girl's left wrist.

male office worker

The most likely clothing for a male office worker is a well-cut suit in a dark colour.

1 Begin by drawing a pencil outline of your figure. Give the character a stance that exudes authority or efficiency.

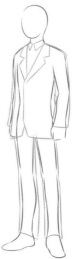

2 Use your outline as a guide for drawing the suit. Use simple lines to achieve the basic shape.

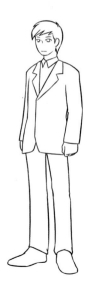

4 Trace the outline of the suit and go over your whole artwork using ink. Draw outlines of the man's shoes.

3 Now trace the outline of your male figure, giving more shape to his natural curves. Give the character some hair and draw in the facial features.

▶▶

male office worker continued

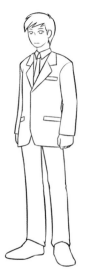

6 Think about the fabric the suit is made of and draw in some lines to show where it is creased.

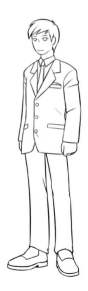

5 Start to add detail. Draw in a tie at the neck and add some pockets to the jacket front.

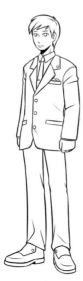

8 Colour your work using dark tones. The soft shadows should be almost black. Add a few subtle highlights where the fabric catches the light.

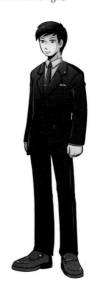

7 Add any final ink details, such as the shading under the worker's chin and the buttons on his suit jacket. Finish the shoes and draw in a tie pin.

punk boy

This punk look is mostly associated with teenagers. It can be adapted for both boys and girls.

1 Begin by drawing a pencil outline of your figure. This character has a slightly rebellious, confrontational stance.

2 Use your outline as a guide for drawing the outfit. Use simple lines to achieve the basic shape.

4 Trace the outline of the outfit and go over your whole artwork using ink. Draw outlines of the boy's shoes.

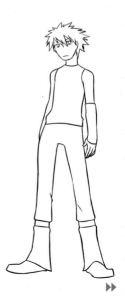

3 Now trace the outline of your male figure, giving more shape to his natural curves. Give the character some hair and draw in the facial features.

▶▶

punk boy continued

5 Draw in the scarf around the boy's neck and the loose belt around his waist. Add armbands and a bondage strip stretching from one leg to the other.

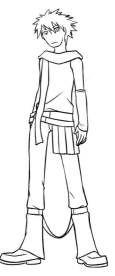

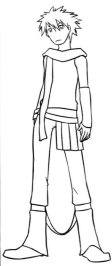

6 Work on the finer details. Draw lines where the armband, t-shirt and pants have creases. Give more shape to the shoes.

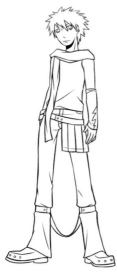

8 Colour your work using strong colours. The soft shadows are almost black. Add a few subtle highlights where certain materials catch the light.

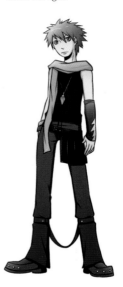

7 Add any final ink details, such as the shading under the punk's chin and the decorative details on his armband, bondage strip and shoes.

gothic boy

The gothic look is intentionally dark and freakish. Male goths tend to have an effeminate quality, too.

1 Begin by drawing a pencil outline of your figure. Give your character a stance that is in keeping with his outfit.

2 Use your outline as a guide for drawing the outfit. Use simple lines to achieve the basic shape.

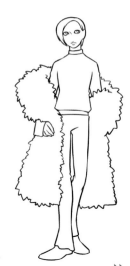

4 Trace the outline of the outfit. Consider any accessories, such as this huge, fluffy wrap. Go over your outline in ink.

3 Now trace the outline of your male figure, giving more shape to his natural curves. Give the character some hair and draw in the facial features.

▶▶

gothic boy continued

5 Work on the boy's shirt. Draw in the front seam and elaborate on the frilly cuff. Add the decorative feather feature.

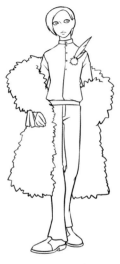

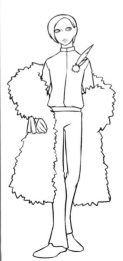

6 Add more detail. Draw in the zip on the pants and give more shape to the shoes.

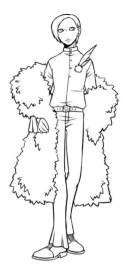

8 Colour your work using rich but dark colours. Keep the shadows soft, particularly for the fluffy wrap. Use subtle highlights where the materials catch the light.

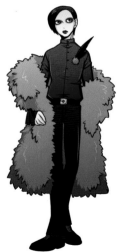

7 Add any final ink details, such as the shading under the goth's chin and creases in his clothes. Work on the texture of the fluffy wrap. Finish the boy's belt and shoes.

gothic girl

This look borders the realms of fantasy, allowing for a greater scope of creativity than many more realistic outfits.

1 Begin by drawing a pencil outline of your figure. Give your character a stance that is in keeping with her outfit. This example is doll-like.

2 Use your outline as a guide for drawing the outfit. Use simple lines to achieve the basic shape.

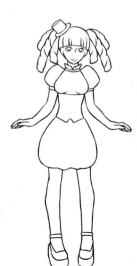

4 Trace the outline of the outfit. Consider any accessories, such as the fun-size top hat and the wedged shoes. Go over your outline in ink.

3 Now trace the outline of your female figure, giving more shape to her natural curves. Give the character some hair and draw in the facial features.

▸▸

gothic girl continued

5 Work on the girl's outfit. Draw in the hoop structure of the skirt, give shape to the bodice and give the girl stripy tights.

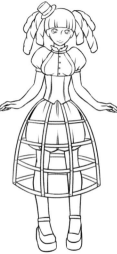

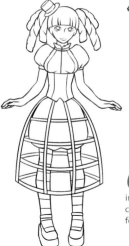

6 Think about the fabrics you have chosen. Draw in a number of pleats to capture the gathers and folds of the puff-ball skirt.

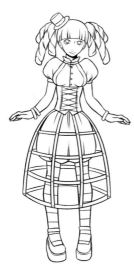

8 Colour your work using rich but dark colours. Keep the shadows soft and subtle. Use highlights sparingly to show where the hair, clothes and shoes catch the light.

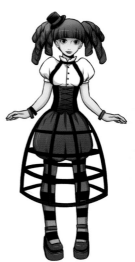

7 Add any final ink details, such as the shading under the goth's chin and the ties on her bodice. Give the girl some jewellery and finish her shoes.

hip-hop boy

The hip-hop look is easy to create and can be adapted for teenage boys or girls.

1 Begin by drawing a pencil outline of your figure. This character has a relaxed and confident, streetwise stance.

2 Use your outline as a guide for drawing the outfit. Use simple lines to achieve the basic shape.

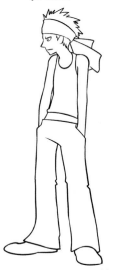

4 Trace the outline of the outfit, adding creases at the knees of the pants. Go over your work using ink. Draw outlines of the boy's shoes.

3 Now trace the outline of your male figure, giving more shape to his natural curves. Give the character some hair and draw in the facial features.

▶▶

hip-hop boy continued

5 Give more shape to the scarf tied around the boy's head. Work creases into the legs of his pants and draw a line to show the boy's visible underpants.

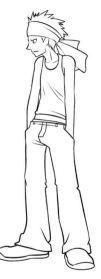

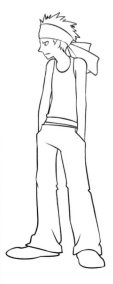

6 Work on the finer details. Add lines for the creases in the boy's vest. Draw in the zip at the top of the pants and elaborate on the shoes.

7 Add any final ink details, such as the shading under the boy's chin, the decorative details on the headscarf and the laces on the shoes. Add some jewellery and a tattoo.

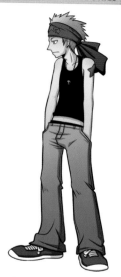

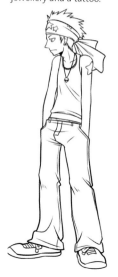

8 Colour your work. Use flat colour to capture the stiffness of the denim pants. The nature of the fabrics means that there are no sharp highlights.

GALLERY

BELOW Looking glam in fur coat, mini skirt and pink fur-trimmed platform boots with pompoms.

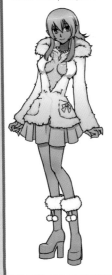

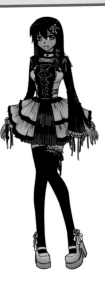

ABOVE A new-romantic look with a layered, bodice-type dress. Plenty of frills and floral decorations.

BELOW A cutesy baby-doll look with PVC handbag and strappy heels.

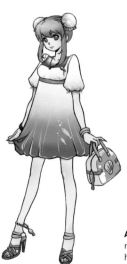

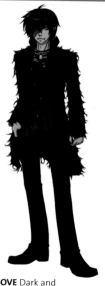

ABOVE Dark and mysterious, this character has a hint of glamour, with eye patch and shaggy coat.

military uniform

When it comes to military uniforms, there are plenty of styles to take inspiration from.

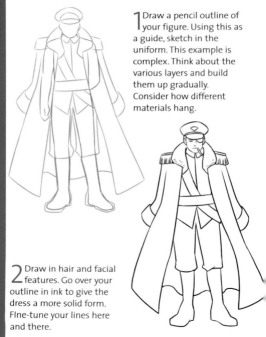

1 Draw a pencil outline of your figure. Using this as a guide, sketch in the uniform. This example is complex. Think about the various layers and build them up gradually. Consider how different materials hang.

2 Draw in hair and facial features. Go over your outline in ink to give the dress a more solid form. FIne-tune your lines here and there.

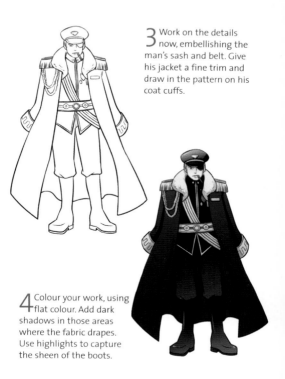

3 Work on the details now, embellishing the man's sash and belt. Give his jacket a fine trim and draw in the pattern on his coat cuffs.

4 Colour your work, using flat colour. Add dark shadows in those areas where the fabric drapes. Use highlights to capture the sheen of the boots.

medical outfit

This is the sort of outfit a doctor might wear, its main feature being the long white coat.

1 Draw a pencil outline of your figure. Using this as a guide, sketch in the clothing. This man wears a regular shirt and tie with pants beneath the coat.

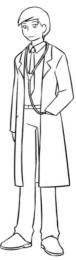

2 Draw in hair and facial features. Go over your outline in ink. Add the shoes, belt and a stethoscope.

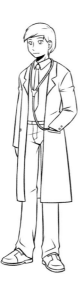

4 Colour your work, using flat colour. Use soft grey shadows to make the white coat look realistic. Keep highlights to a minimum.

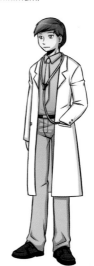

3 Work on the finer details now – the shadow beneath the man's chin, the buttons on his coat and the creases in his clothing. Finish the shoes.

policeman's uniform

Police uniforms differ from country to country, so there are plenty of examples to base your designs on.

1 Draw a pencil outline of your figure. Using this as a guide, sketch in the man's uniform. This example has a belted jacket and a peaked cap.

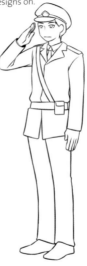

2 Draw in hair and facial features. Go over your outline in ink, adding detail to the hat and belt. Draw in the man's shoes.

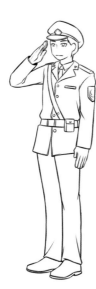

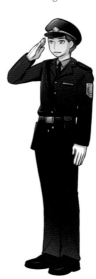

4 Colour your work, using a flat, dark colour. The shadows in the creases will be black. Use highlights to show where the uniform catches the light.

3 Work on the finer details now – the creases in the man's jacket and pants, the badge on his arm and the texture of his gloves. Finish the shoes.

fireman's outfit

The key to this outfit is that the styling must be practical and the clothes made out of a protective material.

1 Draw a pencil outline of your figure. Using this as a guide, sketch in the man's uniform. He is protected from head to toe.

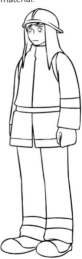

2 Draw in facial features. Go over your outline in ink, adding detail to the helmet and pants. Draw the belt, gloves and shoes.

4 Colour your work, using appropriate colours – in this case orange and yellow. Add soft shadows and use highlights to show where the uniform catches the light.

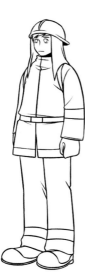

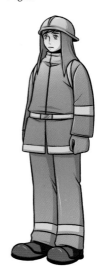

3 Work on the finer details now – the uniform is made of heavy-duty material, so creasing is minimal. Finish the man's shoes.

GALLERY

BELOW A female car mechanic in a practical grey jumpsuit.

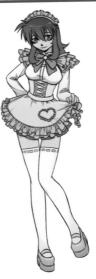

ABOVE This waitress wears the kind of outfit you might see in an American-style themed diner.

BELOW The practical clothing of a woman police officer. Simple shirt and skirt with tan tights.

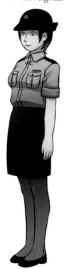

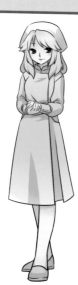

ABOVE The sort of outfit a nurse might wear. For hygiene reasons she wears a plain gown and hat.

winged heroine

When it comes to dreaming up fantasy characters for your stories, you can really start to stretch your imagination.

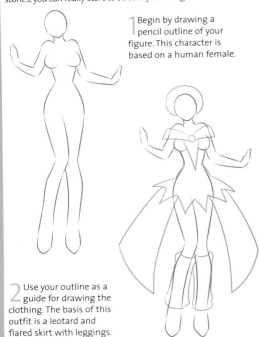

1 Begin by drawing a pencil outline of your figure. This character is based on a human female.

2 Use your outline as a guide for drawing the clothing. The basis of this outfit is a leotard and flared skirt with leggings.

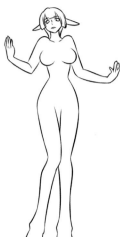

4 Trace the outline of the outfit, fine-tuning the shape. Go over your outline in ink.

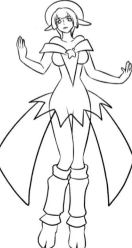

3 Now trace the outline of your figure. Give the character some hair and draw in the facial features. Add fantasy elements to the human form, giving the character goat-like ears and cloven feet.

▶▶

winged heroine continued

5 Add more detail, such as the decorative elements on the leotard and the flared skirt.

6 Elaborate on the fantasy element. This character has feathered wings at the hips, and feathers at the shoulders and ankles.

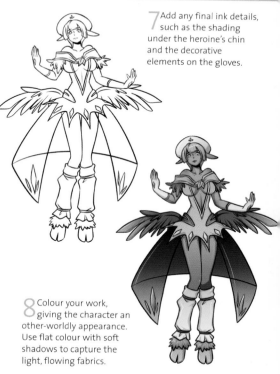

7 Add any final ink details, such as the shading under the heroine's chin and the decorative elements on the gloves.

8 Colour your work, giving the character an other-worldly appearance. Use flat colour with soft shadows to capture the light, flowing fabrics.

masked knight

Here is an outfit that combines fabrics with metal finishes. Take care in making each material look realistic.

1 Begin by drawing a pencil outline of your figure. Give your character a stance that is in keeping with his outfit.

2 Use your outline as a guide for drawing the clothing. This outfit combines an armour suit with a flowing cape.

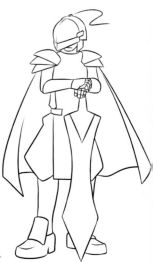

4 Trace the outline of the outfit, fine-tuning the shape. Draw in the knight's sword. Go over your outline in ink.

3 Now trace the outline of your male figure. Most of this character's body is obscured beneath his outfit, so details are minimal – particularly when it comes to the face.

▶▶

masked knight continued

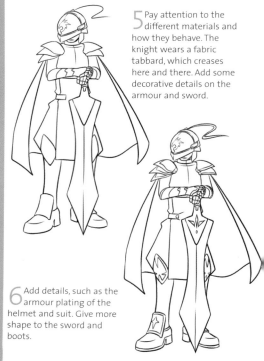

5 Pay attention to the different materials and how they behave. The knight wears a fabric tabbard, which creases here and there. Add some decorative details on the armour and sword.

6 Add details, such as the armour plating of the helmet and suit. Give more shape to the sword and boots.

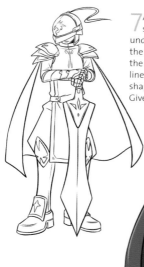

7 Add any final ink details, such as the shading under the knight's chin and the decorative elements on the epaulettes. Add a few lines to emphasise the shape of the chest plate. Give the tabbard a border.

8 Colour your work, using strong masterful colours. Use soft shadows on the fabric areas and bright, sharp highlights on the metal surfaces.

GALLERY

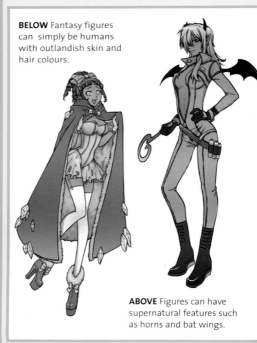

BELOW Fantasy figures can simply be humans with outlandish skin and hair colours.

ABOVE Figures can have supernatural features such as horns and bat wings.

BELOW Use animal features, such as pig's trotters for a surreal effect.

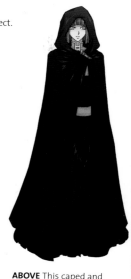

ABOVE This caped and hooded character exudes a dark, mysterious element.

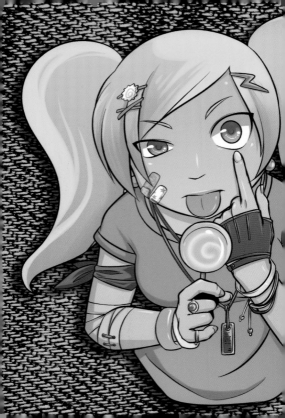

accessories

In this section you will discover how to draw and colour all manner of accessories, from hats and bags to sunglasses, gloves and jewellery. Each project considers the types of material involved – including precious metals, leather, knitwear and plastics – and how best to render them easily and realistically.

floppy hat

This floppy hat has a uniform shape with a narrow, flared brim. It is very easy to draw.

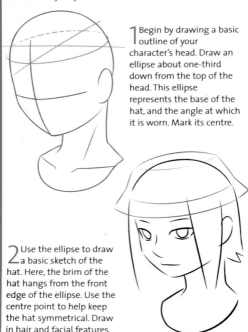

1 Begin by drawing a basic outline of your character's head. Draw an ellipse about one-third down from the top of the head. This ellipse represents the base of the hat, and the angle at which it is worn. Mark its centre.

2 Use the ellipse to draw a basic sketch of the hat. Here, the brim of the hat hangs from the front edge of the ellipse. Use the centre point to help keep the hat symmetrical. Draw in hair and facial features.

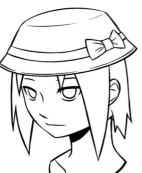

3 Work on any additional details – the ribbon tied in a pretty bow, the seam at the edge of the hat brim, the structure and shading of the neck area. Go over your drawing in ink and erase any unwanted pencil lines.

4 Now you can add colour to your artwork. Use flat colour to capture the softness of the fabric. The light is coming from the front, so work in soft shadows to the rear of the hat.

baseball cap

A wardrobe staple for boys and young men, the baseball hat may also be worn by girls.

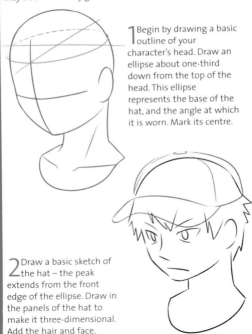

1 Begin by drawing a basic outline of your character's head. Draw an ellipse about one-third down from the top of the head. This ellipse represents the base of the hat, and the angle at which it is worn. Mark its centre.

2 Draw a basic sketch of the hat – the peak extends from the front edge of the ellipse. Draw in the panels of the hat to make it three-dimensional. Add the hair and face.

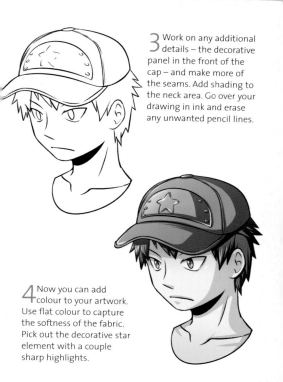

3 Work on any additional details – the decorative panel in the front of the cap – and make more of the seams. Add shading to the neck area. Go over your drawing in ink and erase any unwanted pencil lines.

4 Now you can add colour to your artwork. Use flat colour to capture the softness of the fabric. Pick out the decorative star element with a couple sharp highlights.

beanie hat

A popular choice for young men, the beanie hat can also make up part of a character's uniform.

1 Begin by drawing a basic outline of your character's head. Draw an ellipse about one-third down from the top of the head. This ellipse represents the base of the hat, and the angle at which it is worn. Mark its centre.

2 Use the ellipse to draw a basic sketch of the hat. The front edge of the ellipse forms the headband, with the hat flopping over at the front and back. Draw in hair and facial features.

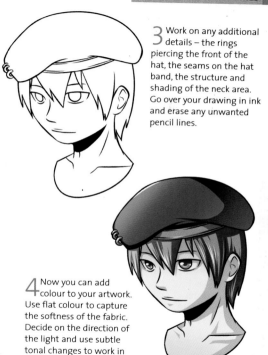

3 Work on any additional details – the rings piercing the front of the hat, the seams on the hat band, the structure and shading of the neck area. Go over your drawing in ink and erase any unwanted pencil lines.

4 Now you can add colour to your artwork. Use flat colour to capture the softness of the fabric. Decide on the direction of the light and use subtle tonal changes to work in soft shadows.

GALLERY

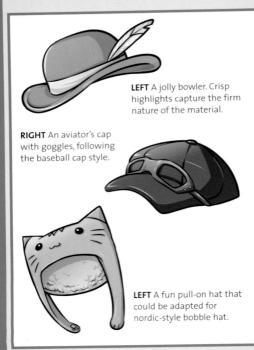

LEFT A jolly bowler. Crisp highlights capture the firm nature of the material.

RIGHT An aviator's cap with goggles, following the baseball cap style.

LEFT A fun pull-on hat that could be adapted for nordic-style bobble hat.

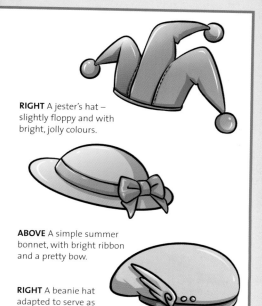

RIGHT A jester's hat – slightly floppy and with bright, jolly colours.

ABOVE A simple summer bonnet, with bright ribbon and a pretty bow.

RIGHT A beanie hat adapted to serve as part of a naval uniform.

messenger bag

Messenger bags are used by boys and girls alike. You can adapt this model to suit any character.

1 Start by drawing a pencil outline of your figure. Decide on an appropriate stance and consider proportion and perspective.

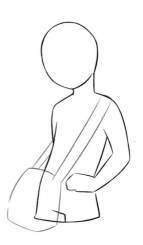

2 Using your pencil outline as a guide, sketch in the bag. Here it is slung over the boy's head from left shoulder to right hip. Draw its basic shape.

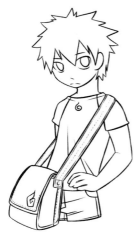

3 Build on your character. Draw in his hair and facial features and give him some clothes. Add details to the bag – stitching in the leather, rivets for the straps and an emblem on the front.

4 Colour your work. The leather of the bag is a warm, soft brown. Work in some darker tones for the shadows. Add smooth, subtle highlights where it catches the light. Go over your drawing in ink.

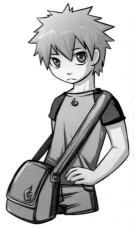

girl's party clutch bag

Party bags tend to be small, simple bags without straps.
They are often made of fun or luxuriant materials.

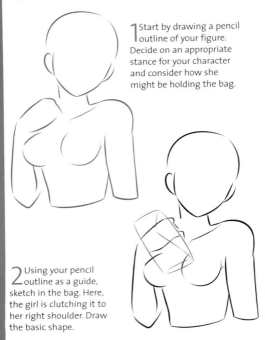

1 Start by drawing a pencil outline of your figure. Decide on an appropriate stance for your character and consider how she might be holding the bag.

2 Using your pencil outline as a guide, sketch in the bag. Here, the girl is clutching it to her right shoulder. Draw the basic shape.

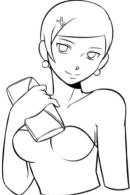

3 Build on your character. Draw in her hair and facial features and give her some clothes. Add details to the bag, such as any stitching or seams. Go over your drawing in ink.

4 Colour your work. Here, the colours of the clutch bag complement those of the girl's hair and dress. Work in some soft shadows and minimal highlights.

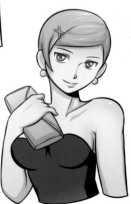

girl with backpack

The design of this backpack is intended for a young girl, so it has a number of fun elements.

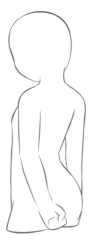

1 Start by drawing a pencil outline of your figure. Decide on an appropriate stance for your character This girl is viewed from the back.

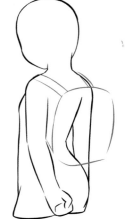

2 Using your pencil outline as a guide, sketch in the backpack. Consider the size of the bag and make sure it fits with the girl's proportions.

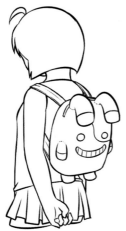

3 Build on your character. Draw in her hair and facial features and give her some clothes. Add details to the bag, such as the fun elements used here. Draw in the zip. Go over your drawing in ink.

4 Colour your work using fun colours. Use high contrast between shade and light to capture the sheen of the material. Drop in some sharp highlights.

GALLERY

ABOVE A worker's lunch bag – small and compact with a rigid structure.

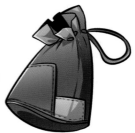

RIGHT A lightweight fabric tote bag, with decorative patches and a drawstring.

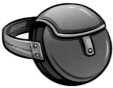

LEFT A small handbag, suitable for ladies' evening wear. Compact and very easy to carry.

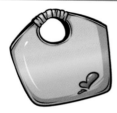

LEFT A lady's summer shopping bag, simple in shape for ease of use.

RIGHT A child's backpack in the shape of a fun character.

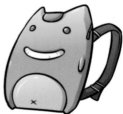

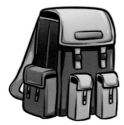

LEFT A labourer's practical backpack. It has a rigid structure and plenty of handy pockets.

scarf

Scarves can be worn tied at the neck or simply draped around the shoulders. Materials are usually soft knits.

1 Start by drawing a pencil outline of your figure. Decide on an appropriate stance and how the character will be wearing the scarf.

2 Using your pencil outline as a guide, sketch in the scarf. Here it is wrapped around the girl's shoulders. Draw its basic shape.

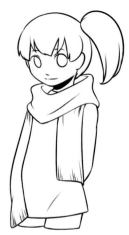

3 Build on your character. Draw in her hair and facial features and give her some clothes. Mark the shading beneath her chin. The scarf is made from soft knitted wool. Draw in some lines to give it texture. Go over your drawing in ink.

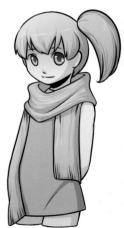

4 Colour your work. This scarf is a soft pink. Work some shadows into the folds, adding highlights to the top edges.

leather gloves

These leather gloves are fingerless, but you could easily adapt them to have full fingers or mitten hands.

1 Start by drawing a pencil outline of the hand. Decide on the shape it will take and consider the right proportions and perspective.

2 Using your pencil outline as a guide, sketch in the glove. Use a few simple lines to draw its basic shape.

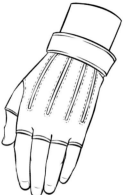

3 Work on the finer details. This is a leather glove with stitching. Draw in all of the seams. Give more shape to the hand, adding knuckles and fingernails. Go over your drawing in ink.

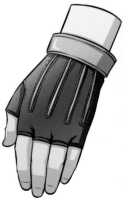

4 Colour your work. The leather is two-tone in soft, warm shades. Use flat colour and be careful not to lose the stitching lines. Work in soft shadows and highlights where the leather catches the light.

sunglasses

You can use this example as a model for any character with sunglasses. Vary the style of the glasses to suit.

1 Draw a pencil outline of the head. The eyes are about one-third up from the chin. Because this is a three-quarter view, they are centred on a line that is one-third in from the right-hand side of the face. Draw outlines of the glasses.

2 Work on the rest of your character, drawing in hair and facial features. Draw in the frame for the glasses, making sure you get the perspective right.

3 Go over your drawing in ink and erase any unwanted pencil lines. Add a strong shadow beneath the girl's chin.

4 Colour your work. It is important to capture the reflective nature of the plastic glasses. Use high-contrast shading to achieve this, with no blending of light and dark.

aviator hat & glasses

This project combines principles used for drawing a baseball cap and the sunglasses on the previous page.

1 Draw a pencil outline of the head. The eyes are about one-third up from the chin. Because this is a three-quarter view, they are centred on a line that is one-third in from the right-hand side of the face. Draw outlines of the glasses.

2 Work on the rest of your character, drawing in hair and facial features. Draw in a basic outline for the hat and aviator glasses.

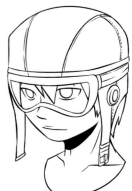

3 Go over your drawing in ink. Add extra details, such as the stitching on the hat and buckles for the straps. Add a dark shadow beneath the boy's chin.

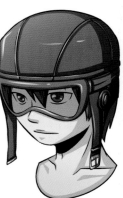

4 Colour your work. The hat and glasses are made from hard, semi-rigid materials and so should have sharp highlights where they catch the light.

belt

There is no end to the different types of belt that you can draw for both male and female characters.

1 Start by drawing a pencil outline of your figure. Decide on an appropriate stance and how the character will be wearing the belt.

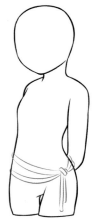

2 Using your pencil outline as a guide, sketch in the belt. Here it is draped loosely around the girl's waist with a knot at the left-hand side.

3 Build on your character. Draw in her hair and facial features and give her some clothes. Mark the shading beneath her chin. The belt is made from soft woven cord. Give it a crinkly texture. Go over your drawing in ink.

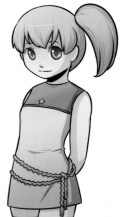

4 Colour your work. This belt is a soft orange colour. Work in some subtle shading.

watch

Watches come in all shapes and sizes. Consider the different materials they might use, from fabrics to plastics and metals.

1 Start by drawing a pencil outline of the hand. Decide on the shape it will take and consider getting the right proportions and perspective early on.

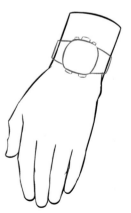

2 Using your pencil outline as a guide, sketch in the watch over the wrist area. Use a few simple lines to draw its basic shape.

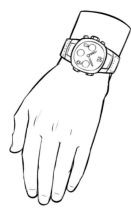

3 Work on the finer details. This watch has a number of technical features. Give more shape to the hand, adding knuckles and fingernails. Go over your drawing in ink and erase any unwanted pencil lines.

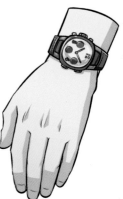

4 Colour your work. The watch is made from a flexible plastic material. Use soft tones for the shadows and pick out some crisp highlights.

bangles

You can use this project as a model for a wide variety of bracelets and bangles.

1 Start by drawing a pencil outline of the hand. Decide on the shape it will take and consider getting the proportions and perspective right.

2 Using your pencil outline as a guide, sketch in the bangles. Use a few simple lines to draw their basic shapes.

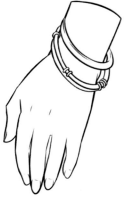

3 Firm up the outlines of the bangles, adding any extra decorative details. Give more shape to the hand, adding knuckles and fingernails. Go over your drawing in ink.

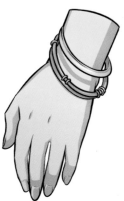

4 Colour your work. The bangles are made from a hard plastic. Use sharp highlights to give them a rigid, three-dimensional appearance.

large ring

Rings can be worn by both men and women and can follow almost any style.

1 Start by drawing a pencil outline of the hand. Decide on the shape it will take and consider the right proportions and perspective.

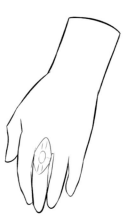

2 Using your pencil outline as a guide, sketch in a ring on your chosen finger. Use a few simple lines to draw its basic shape.

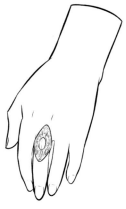

3 Work on the finer details. This is a large gold ring with engravings and a central stone. Give more shape to the hand, adding knuckles and fingernails. Go over your drawing in ink.

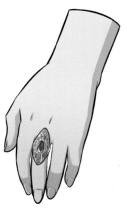

4 Colour your work. It is important to capture the curved shape of the ring. Use subtle changes of tone to show this, and bright highlights.

necklace

You can add all manner of decorative jewellery around a character's neck. The principles for drawing are the same.

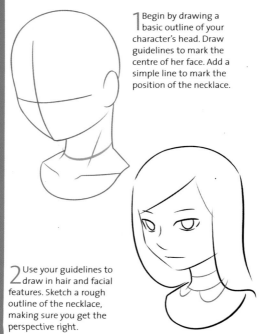

1 Begin by drawing a basic outline of your character's head. Draw guidelines to mark the centre of her face. Add a simple line to mark the position of the necklace.

2 Use your guidelines to draw in hair and facial features. Sketch a rough outline of the necklace, making sure you get the perspective right.

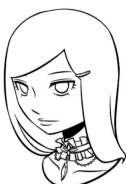

3 Elaborate on the facial features and draw in a shadow beneath the girl's chin. Work on the design of the necklace, defining its shape and adding the jewels. Go over your drawing in ink and erase any unwanted pencil lines.

4 Colour your work. Use flat colours for the fabric elements of the necklace. Add sharp highlights to capture the sparkle of the jewels.

hairband

This is a simple, painted metal hairband. Use the same principles to draw bandanas, alice bands and headscarves.

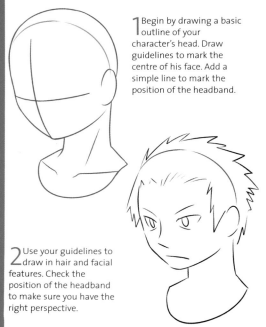

1 Begin by drawing a basic outline of your character's head. Draw guidelines to mark the centre of his face. Add a simple line to mark the position of the headband.

2 Use your guidelines to draw in hair and facial features. Check the position of the headband to make sure you have the right perspective.

3 Elaborate on the facial features and draw in a shadow beneath the boy's chin. Work on the design of the headband, defining its shape. Go over your drawing in ink and erase any unwanted pencil lines.

4 Colour your work. The headband is made of painted metal, so should have sharp highlights where it catches the light.

earrings

Earrings range from small metal studs through hooped rings to elaborate dangles.

1 Begin by drawing a basic outline of your character's head. Draw a guideline to mark the centre of her face.

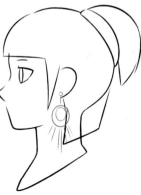

2 Use your guideline to draw in hair and facial features. Sketch a basic outline of the earring.

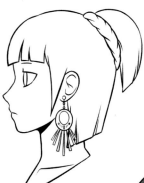

3 Elaborate on the facial features and draw in a shadow beneath the girl's chin. Work on the design of the earring, adding any decorative elements. Go over your drawing in ink and erase any unwanted pencil lines.

4 Colour your work. The earring is made of gold, so should have bright highlights where its surfaces catch the light.

GALLERY

RIGHT This girl wears head phones and a matching choker.

LEFT A sea nymph with elegant silver headband and earrings.

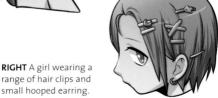

RIGHT A girl wearing a range of hair clips and small hooped earring.

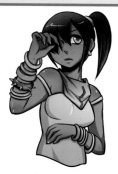

LEFT A girl wearing multiple brightly coloured and studded bangles.

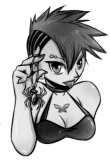

RIGHT A tattooed punk with pierced eyebrows, ears and tongue.

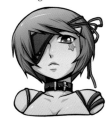

LEFT A boy with an eye patch and buckled, leather choker.

GALLERY

RIGHT A boy using head phones. His hair is pinned back with clips.

LEFT A jester-type character with belted bumbag and gold armbands.

RIGHT A male character with eyepiece and an emerald pendant.

LEFT A teenager wearing metal tags and fingerless leather gloves.

RIGHT School kid with pull-on pompom hat and backpack.

LEFT Sinister character with a fur-trim hoodie and fingerless gloves.

index

▶▶

index